Collage in the
Classroom

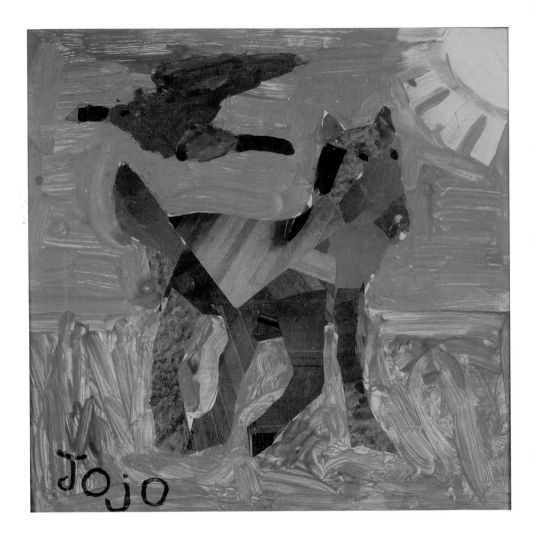

Collage in the Classroom

Ann Manie

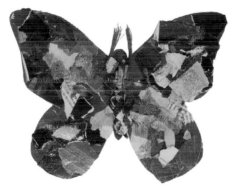

A & C Black • London

First published in Great Britain in 2008
A & C Black Publishers Limited
38 Soho Square
London W1D 3HB
www.acblack.com

ISBN: 978-0-7136-8903-7
Copyright © 2008 Ann Manie

CIP Catalogue records for this book are available from the British Library.

Book design: Susan McIntyre
Cover design: James Watson
Commissioning Editor: Linda Lambert
Editor: Sophie Page

Typeset in 11 on 13pt Minion
Printed and bound in China

Contents

Acknowledgements

Where to begin in thanking the many people that have helped to make this book happen? My husband Barry for his immense support, love and insightful comments; Michael Spencer-North and Guy Rose for their invaluable advice, the publishers A & C Black, who recognise that collage is a valid artistic medium and has an important role to play in children's art education; the gentle and subtle support of Angela Rudge-Litten, my tutor at art college and subsequent friend of 25 years; Sharon Edmunds, a former teacher, who suggested that my work in collage could be adapted for use in school projects and introduced me to Highgate Pre-preparatory School; the Headmistresses of that school – Barbara Rock (now sadly deceased) and currently Julia Challender – for their wonderful practical support and kindness; numerous teachers, classroom assistants and parents who assisted in the preparation for and the running of the workshops – particularly keeping the very young children focused on the project in hand!

The biggest acknowledgment though must go to the stars – all the children over many years, whose wonderful exciting collages are the fruits of commitment, hard work, enthusiasm and artistic talent! I thank them and their parents for permitting me to print the collages, which, I hope, will inspire many others to follow in their footsteps.

Barney Newman is responsible for the majority of the photographs: I wish to acknowledge the high quality of the images which he provided but also to thank him for the extra help he gave in assembling the finished 'Water-Lilies' collage.

I am very grateful for the permission from DACS for the licence to include Picasso's collage of *Bar Table with Guitar*, spring 1913; from the Natural History Museum, South Kensington, London, to include their photos of minerals from their collection as well as photos taken by myself of children drawing at the Museum; The Tate Modern for the licence to print Monet's *Water-Lilies*. Every care has been taken to trace copyright holders, but if there have been any omissions or failure to obtain permissions, I sincerely apologise and will, if informed, endeavour to make corrections in any future edition of this book.

1 Introduction

This book aims to introduce teachers, schoolchildren and possibly anyone who has an interest in art, to the wonderful creative possibilities of the medium of collage, and particularly paper collage. Collage within the field of art and design is best described as 'the use of different artefacts, such as paper, cardboard and a variety of fabrics, which are pasted on, or attached to, a surface in order to create a design or picture' .

The main intention of this book will be to show how collage can play an important part in the learning process, filtering into subjects of the National Curriculum, providing fun and enrichment in its wake. Collage is a lightweight, inexpensive activity which does not require vast areas of space – it can be produced on a small table, on the floor or even in the open air (on a sunny windless day!). Exciting results can be achieved in simple surroundings using basic materials in the space of 45 minutes – the length of a school lesson.

In this book, I describe the topical subject matter of various collage workshops from preparation to completion, and explain why collage is a sympathetic medium for these particular projects. Chapter 3 includes a Lesson Plan for a teacher to follow, where the children can create their own individual collages, drawing inspiration from their immediate surroundings. I have not encountered any educational books offering quite the same view of paper collage which includes a clear and practical guide on how to do it.

Collage is a technique that is quick to do, there is no right or wrong way to cut, tear and paste and any mistakes can be papered over. Professional artists, students, hobbyists and young children can all use collage as a medium to explore, develop and express new ideas and ways of seeing the world. In writing this book I am attempting to give this wonderful medium, which has been a bit neglected in recent years, a greater prominence, particularly in the early stages of art education. In sharing my experiences with others I hope to provide enjoyment and a flowering of creative opportunities for teachers and pupils.

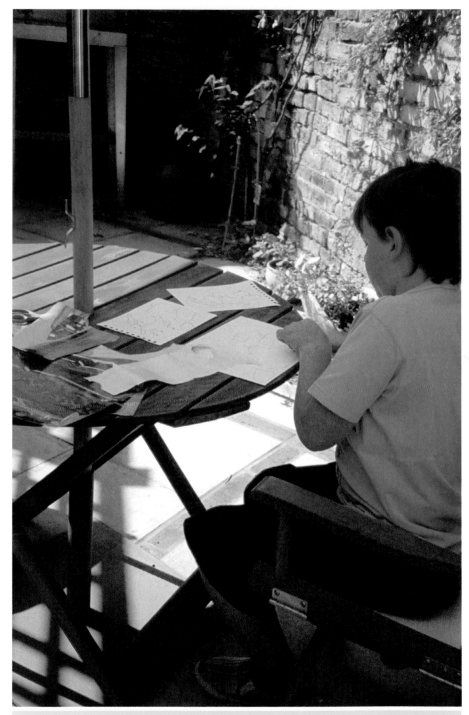

Working in the open air

2 Personal Reflections

My own initiation to collage came about in the classroom when I was nine years old, at St Anselm's Primary School in Dartford, Kent. In those days being good at arithmetic and English, and passing the 11-plus exam were, one was led to believe, the key to any sort of future worth having. Nothing else mattered and its importance seemed to overshadow everything. One spring, the headmistress of the school, a nun called Sister Agnes, decided to run an art class for an afternoon, which was unusual and a wonderful release from arithmetic. The art class involved the use of paper collage – we had to create any image using coloured paper from the magazines that Sister Agnes had brought with her. It could be cut or torn and pasted onto a large sheet of white cartridge paper (A2 size, which is big when one is nine years old). I remember creating a spring landscape with grass, flowers and blue sky, and being happy in the classroom for the first time ever! I have a peaceful and positive memory of this activity at a time when the atmosphere was generally so serious.

To my surprise the collage aroused more than a passing interest; some even remarked that it was the best one! The seeds of something that was to become very important in my life had been sown – I had been hooked by collage and continued in my spare time.

Many years later, at art school, I returned to collage in an endeavour to break free from the struggle that I was experiencing in mastering perspective and proportion in the drawing class. I felt that much of my work was becoming dull and laboured because I became obsessed with the accurate measuring of proportions in order to create an exact representation of what I could see. Tutors seemed to confirm this, with the polite remark: 'the work, although competent is a bit dull and lifeless'. In desperation I turned to collage, selecting and cutting out coloured paper from magazines and wallpaper from an interior decorator's sample book. I added to this odd bits of fabric that I had collected over the years – black velvet and pieces of discarded curtain material. I loosely sketched in the image of an interior depicting the objects and shapes from my immediate surroundings – the art

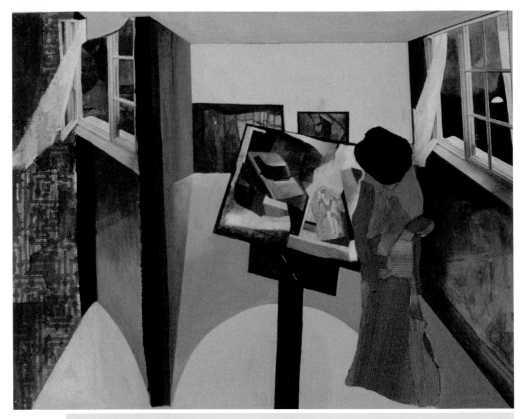

Coat and Easel in an Interior, Ann Manie, 1984

studio with its windows, doors and furniture – an easel with a coat and hat draped over the side of it. As I began to cut and paste the worry about accuracy within the drawing faded. I became absorbed with the tactile quality of the fabrics and the different papers and their beautiful range of colours and textures. Although I was sitting in and near the objects that I had chosen as my subject matter it didn't seem vital to keep looking at them in order to produce this painting.

The materials and the technique of collage developed a strange life of its own. I felt I was inventing and exploring; using memory, imagination and chance when randomly putting together shapes and colours. I held on to my original subject matter (an interior with an easel, hat and coat) but I did feel I was becoming slightly removed from it as I became deeply engaged in exploring the textural qualities of these items – the scuffed easel and the old hat and coat casually slung on to the side of the picture that was on the easel. The desire to fastidiously measure everything had evaporated. I was beginning to understand that exploring the underlying qualities of

the visual tactile world is part of the role of the 'Fine Artist'. Echoes of a familiar statement attributed to the Swiss artist Paul Klee in the early part of the 20th century were coming into my head at that time: 'the purpose of art is not to recreate the visible but to make visible'.

My first encounter with collage in the primary school classroom was, in retrospect, one of many influences. I mention it because it was a positive experience that I drew strength from many years later when I was feeling vulnerable and it highlights my belief that using collage in the classroom can be a liberating experience. As an adult I had seen many collages. During the early years at art school I became fascinated with the work of Cubist painters such as Pablo Picasso, Juan Gris and Georges Braque, particularly their collages. These collages were like a talisman to me – offering a direction and creative path to follow, whereby I could develop as a mixed-media artist working with paper and paint.

I find the medium of collage, and particularly the still-life subject matter that these artists chose to use to express their ideas, enduringly fascinating. Space and objects in the Cubist pictures merge, overlap and interlock into one another. Pablo Picasso's *Bar Table with Guitar* is simpler in composition than many other Cubist pictures, but it has the same features. Space is tipped up, the guitar and bar top merge into each other forming an interesting motif as they interlock. The objects are distorted and broken into facets, they look like they have been drawn from different viewpoints and then assembled together. This was a radical departure from traditional Italian Renaissance painting and perspective drawing techniques, which most artists had been following for centuries, where objects become smaller, and colours and tones become lighter as they recede into the distance. In Cubist paintings, objects and space are given equal prominence, and they seem to hover in a shallow area of space on the surface of the picture.

Picasso's *Bar Table with Guitar* is truly a radical break with the past: objects are deliberately non-illusionistic and the notion of what materials should be used to make a painting or a piece of artwork is being called into question. There is very little if any paint applied, no formal drawing, and large areas are covered with fragments of paper and mass-produced wallpaper that are pasted and stapled on to the surface; yet there is a harmony in the colours, tones and shapes of this arrangement. They entwine and balance with each other on the flat surface of the picture plane, and nothing is in the picture that should not be there. This is what all artists aim to achieve in their work – a quality of balance.

The fragments of wallpaper in this picture reflect socio-economic developments that were taking place in the early 20th century. Due to advancements in mass-production and manufacturing, wallpaper had become an affordable commodity and available to many, rather than an

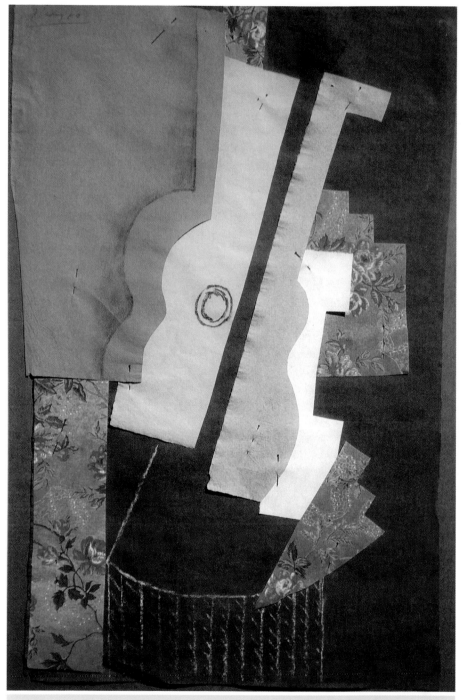

Bar Table with Guitar, Pablo Picasso, 1913

exclusive luxury for the few. The invention of the aeroplane challenged preconceived notions of space and objects. Viewed from the air, space and surrounding objects appear as a flat pattern with no indication of a beginning or end. The ground, people, trees, buildings, streets and fields adopt a new identity; they appear as random shapes in a variety of colours and tones, and the space is ambiguous – are the objects, and people in deep or shallow space? This sensation is mirrored in the Cubists still-life paintings and collages.

The paper in the Cubist artists' collage pictures may have faded just a little, but their concept of how familiar everyday objects could be represented and the type of materials used to make a work of art have endured. Much has been said and written about the Cubist artists and their motives for using collage during the early part of the 20th century. Whatever else is said, Cubism and the technique of collage opened up wonderful opportunities of artistic expression for subsequent artists of the 20th and 21st centuries. This freedom from the constraints of strict observational drawing can be put to good use in teaching art to children.

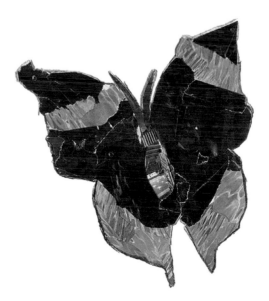

3 An Introductory Collage Lesson

Subject Matter – A Still Life

Pablo Picasso found artistic inspiration from everyday objects for his collages and this chapter will explain how you can follow in his footsteps.

Select an assortment of items that are likely to appear in the classroom:
- pencils, pens, pencil-sharpener
- satchel
- bottles, jars, plastic containers
- cardboard box, tins
- musical instrument
- fruit, flowers, fluffy toys
- ornaments, shells, stones
- clothes – such as a scarf, coat, hat, shoes
- jewellery – watch, bracelet, ring
- etc.

Arrange the items into small groups, considering such things as:
- overall composition of shapes – large next to small
- patterns – dots, circles, straight and curvy lines
- texture – smooth and soft, animate and inanimate

These arrangements can be placed in one spot on a large table, or separated in a variety of locations around the room – for example, on a window-ledge, partially inside a cupboard or next to an open door. Whichever position you choose to place the still-life arrangements in, it is worth considering the quality of light. Is there direct natural sunlight or electric light casting distinctive strong shadows? Is the light falling evenly on the objects? Different lighting can alter the mood of the subject matter. Strong contrasts of light and dark can create a mood of drama and action, whereas even tones and colours evoke a sense of calm and peace.

Although this subject matter is still life – commonly regarded as an arrangement of objects which cannot move – one can create a mood and feeling of life through the arrangement of contrasting shapes, lines, textures and lighting. Below are some examples of different still-life arrangements that might be helpful in your preparation.

Still life arrangements

Still life arrangements

Materials, Equipment and Preparation

There are many types of surfaces that are suitable to paste onto when creating a collage, in fact anything that is flat and generally smooth. For the purpose of a collage lesson white cartridge paper, thin card or pieces of card cut from a discarded cardboard box will do. Cut the card into pieces measuring approximately A4 size. With children working on individual collages, in a lesson that lasts 45 minutes, a small-scale picture is preferable for good results.

Non-toxic PVA glue thinned with water is a suitable adhesive, as is a paste made by preparing flour and water (3 parts water to 8 parts plain flour, stirring continually). The flour and water paste can be made a few hours in advance and stored in an air-tight plastic or glass container. A selection of brushes in any size and small wooden spatulas are an effective means of applying and spreading the glue to the paper (although in practice fingers often seem preferable once the creative spirit takes hold!). Place paste, water and any paint in flat shallow dishes or plastic containers – Indian and Chinese take-away meal containers are really suitable for this. Shallow containers allow the children ease of movement and prevent spillages.

Cutting and sorting different coloured papers in advance is important in a collage lesson – more preparation allows greater time for creativity. Using paper from magazines, cut out areas of different colours and shades. Try not

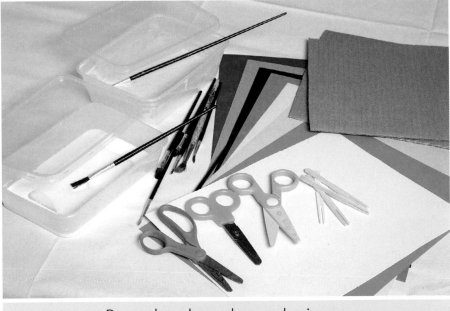

Paper, brushes, glue and scissors

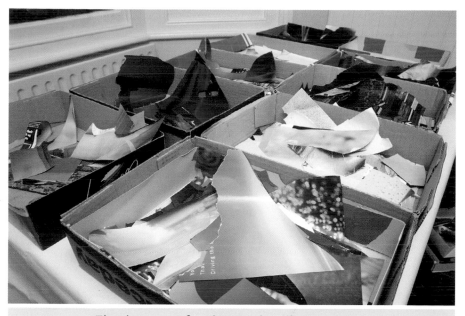

Flat boxes of coloured collage paper

to include photographic imagery such as faces, people, cars, buildings and general scenery. This lesson is about using paper instead of paint to create a picture and it is the colour of the paper that is important, not the images on it. However, if texture and lines appear on the pieces of coloured paper, this is fine, as it will add liveliness and interest to the finished collage.

Place the cut out coloured collage paper in shallow boxes. I find that discarded lids from boxes containing photocopying paper provide excellent storage. One can easily see and select paper when it is displayed in this way. Place the boxes in one place so that the children can easily see the range of colours available when they come to choose their papers. Limit the colours – I recommend three colours plus black and white, because working with too many colours can be confusing.

A selection of poster paints could also be made available but this is optional. Touches of paint, glitter and different fabrics are useful when the work is near completion to simplify or enhance areas and add sparkle – although I recommend using only paper in the first lesson as it is easier to handle.

It is advisable that the children draw their chosen image using pencil or crayon. Charcoal, pastel and paints are more difficult to control when sketching an initial image and can leave too many marks which may conflict with the paper collage. Paint can be applied towards the end of the collage if necessary to eliminate any unwanted photographic imagery and to simplify the picture.

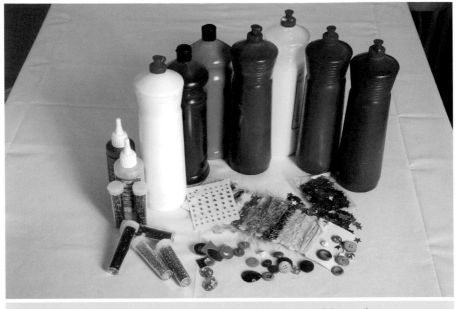

Poster paint, glitter, buttons and braids

Tray of paint

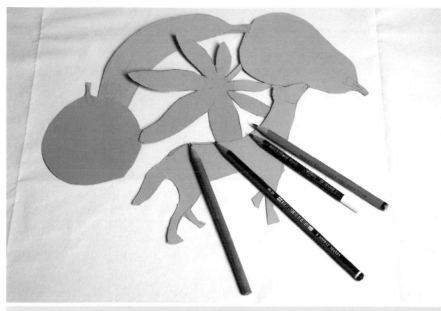

Templates of fruit and horse

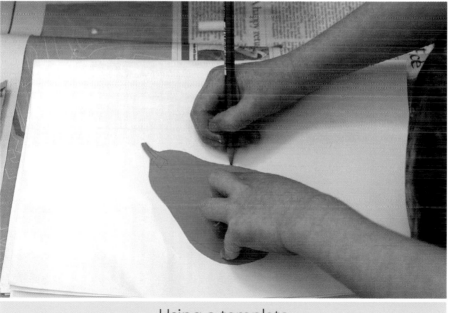

Using a template

Templates are helpful for children to draw around. In advance of the lesson, the teacher could draw and cut out templates of images that relate to the subject so the children can focus on shapes, colour and cutting out and gluing paper. Worrying about producing an exact drawing at the beginning of this lesson is not necessary and can slow up the creative process, preventing wonderful colourful surprises that may occur within the collage. Generally, children aged between 4 to 6 years like to use a template. Protective clothing such as a large shirt or apron should be worn by the children and small childrens' scissors provided.

Examples of paintings of everyday objects painted by famous artists can be used to stimulate ideas at the beginning of the lesson. Local libraries are usually a good source of art history information. Perhaps select four famous artists, one from 300 years ago, one from a 100 years ago, one from 50 years ago and one living artist. Still-life pictures executed in a range of media, as well as collage, could be chosen.

Preparation is crucial to the successful outcome of a collage lesson and this can take place a few days before. Pupils, their siblings and parents could participate in the paper preparation – collecting magazines and cutting out and sorting the different coloured papers at home. 'Family paper preparation homework' has happened in the past, and I am told it encouraged dialogue, intrigue and fun.

Creating and distributing a simple hand-out is effective in getting the lesson started, the following example may be useful:

Lesson Plan

A Lesson Plan can be very helpful when organising a collage lesson. It fulfils a number of functions:

- as a useful time planner to identify the activities and roles of teacher and pupil at various stages of the lesson
- as a reminder of the tools and equipment required
- as a schedule to help keep in mind the tasks required to achieve the aim from the outset
- as an overall guide if things become chaotic!

CREATE A COLLAGE PICTURE FROM OBJECTS IN THE ROOM

1. Choose an object or group of objects that you would like to make a collage picture from. Sketch this out with pencil or crayon on your paper or piece of card. Draw large shapes first and the smaller ones later. Fill the whole of your paper or card.

2. Colours – write down the main colours of your picture.

3. Identify large and small shapes. Are there circles, ovals, squares, rectangles, lines? Draw these in the space below.

4. Texture – will there be smooth and rough surfaces in your picture? Can you see any patterns – such as lines, dots or swirls? Draw them in the space below.

5. Select the colours from the boxes. Choose three colours, and black and white if needed.

6. Cut or tear and paste paper to the large areas first and then work on the smaller areas later.

7. Add paint to enhance or simplify areas if required and also to take out any unwanted photographic imagery such as heads, people, buildings and general scenery.

8. Apply glitter, tinsel or perhaps shiny fabric if you feel that the overall effect needs a little extra sparkle – this is optional and in most cases not required.

Sample Handout

LESSON PLAN

Course: Paper Collage **Time of Class:** 2–2.45pm **Duration:** 45 minutes

Aims: Each pupil to complete a picture using the medium of paper collage (use of paint and other materials at the final stages of the painting is optional) from an arrangement of still-life objects.

Time	Equipment and Materials	Objectives	Teacher Activity	Pupil Activity	Assessment
2.00–2.10pm	Introduction: Still-life arrangements. Art books.	Explain topic: show selection of still-life arrangements. Discuss historical aspect – show still-life pictures by famous artists especially collages by the Cubist Artists such as Picasso, Braque, Matisse and others. Brief question and answer session.	Talking.	Listening and observing.	Has enthusiasm begun to develop from children – i.e. type of questions – historical aspect, technique – why collage?
2.10–2.15pm	Collage materials: Cartridge paper, white, grey or card. Pencils. Scissors, glue, brushes and assortment of different coloured papers in shallow/flat boxes. Selection of paints/ glitter/ fabrics (all optional). Shallow/flat containers to store glue, water and paint. Handout. Template.	Commence small demonstration: make a quick sketch on cartridge paper or card and explain how paper can be cut or torn in order to build up a collage picture. Select 3 or 4 colours and paste a few large shapes, possibly add to this later – no need to complete a picture. Explain – work on large shapes and then small shapes. Explain – look for dark and light colours and tones. Explain – choose 3 colours and black and white from selection of cut out magazine papers. Explain – free to choose any other objects. Distribute handout; distribute templates for children 4–6 years.	Demonstrating. Talking.	Listening and observing.	
2.15–2.40pm		Assisting children.		Children working on collages.	
2.40–2.45pm		Arranging work along one side of the classroom and encourage small question and answer session.		Children stop working even if collage appears unfinished and help teacher to display them and also clear up.	

Sample Lesson Plan

LESSON PLAN

Course: _____

Time of Class: _____

Duration: _____

Aims: _____

Time	Equipment and Materials	Objectives	Teacher Activity	Pupil Activity	Assessment

Blank Lesson Plan

Demonstration

A demonstration of a collage from beginning to completion is provided below.

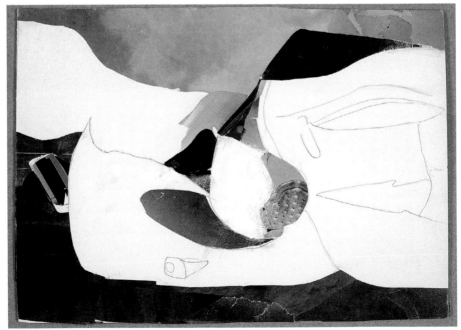

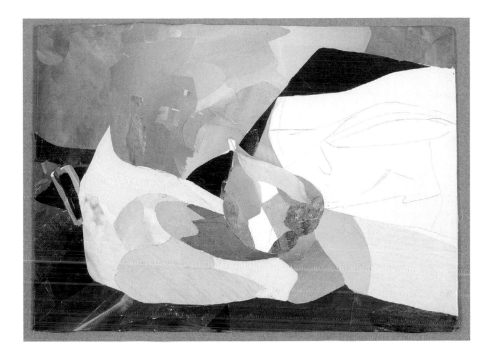

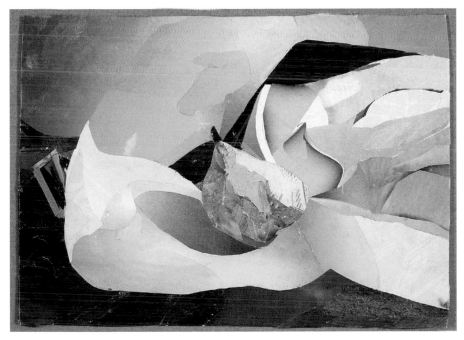

27

Results

Below are examples of work produced by children aged 4 and 9 years at a recent 'Still-life' Collage Workshop.

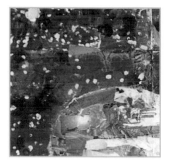

4 Collaborative Projects

In order to create an income from my training and experience as a fine artist I decided to paint murals for children. The imagery of the mural could be based on any subject, for example: characters from well known story books, films, favourite animals or broader based topics such as the planets and marine life. I decided to advertise in popular interior decorating magazines and the response was very positive. The mural painting commissions led to a surprising development of my collage work, which at that time was an activity related exclusively to the fine art work I was doing, and not something I considered could fulfil an educational role.

Most of the commissions were of subjects chosen by the client, which worked very well. I found that once I had done one or two murals, commissions for more arose from friends of the clients I had worked for. It was from this association that I came into contact with a teacher who asked me if I would paint a mural of the planets for her son. While working for her she expressed an interest in looking at my fine art work portfolio. All my portfolio work was in mixed-media, collage and acrylic, and on seeing this she suggested that I might like to do some artwork at her school which would be part of a project on the 'Planets', a topic that was set by the National Curriculum that year. I had never taught before, but I took a leap of faith and accepted the offer.

It was rather scary but I planned it in the same way that I approach a piece of fine art work. I read and researched the subject, made a few drawings, identified an interesting aspect that would work well with art and children aged 5 to 8 years, developed a composition and scale of picture (in this instance one where all the children could take part making it a collaborative work), collected and sorted papers. The sorting of papers was done on a very large scale with the help of parents and children who did this at home and brought in bags of papers that I was able to arrange in flat boxes. The incredible enthusiasm of the children and their parents was unexpected and I am sure that it contributed to what many thought was a very successful result, which led to a further project the following year on the theme of 'Seaworld'.

PLANETS

For this project I created a drawing that extended 92 x 366cm (3 x 12ft), produced on three large pieces of card 92 x 122cm (3 x 4ft) placed side by side. The aim of this art workshop was to make a picture focusing on our solar system and the scale of the sun in relation to the other planets. In advance of this workshop I drew and cut out templates of the sun and planets (drawn approximately to a comparative scale on pieces of card) so that the children could draw around these and then move speedily into collage after the introductory talk.

I had been informed by one of the teachers that there were some very clever children in the school and so I thought it prudent to explain in my introductory talk that I was not an expert in astronomy, but was there to show them possible ways that the planets could be interpreted into a piece of artwork using paper collage. I held up a small-scale sample of how the overall collage would look at the end and this seemed really helpful. After the talk I demonstrated by cutting and tearing and pasting a few pieces of paper on to the card and the children understood immediately what was required. I remained throughout the two days in the art-studio and groups of about 8 to10 children worked on the picture at any one time.

At the end, when the three section panels were completed we put them together and stapled them on to the hardboard panels in the assembly hall. There was time to spare so the children completed two more panels, focussing on satellites, shooting stars and star clusters. I provided books on stars and satellites to generate ideas for the latter pictures.

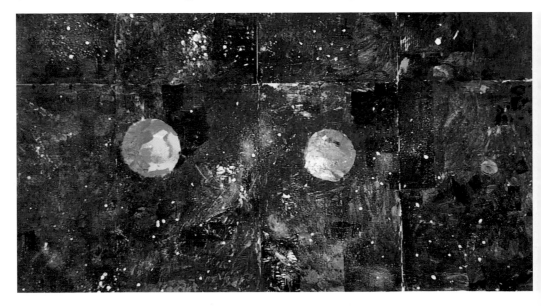

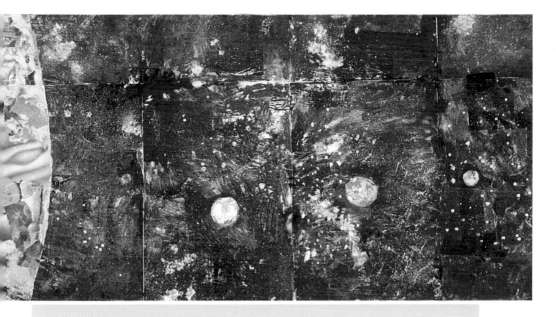

Children's finished Solar System collages

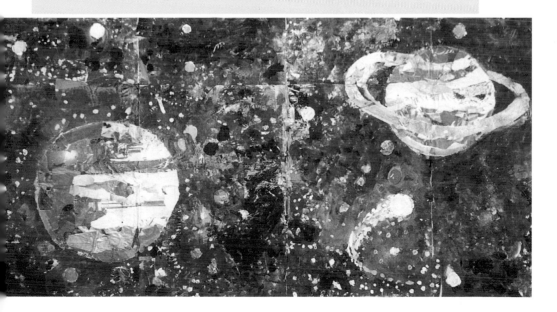

Satellites and Shooting Stars collage

Earth and Space Shuttle collage

The 'Planets' project went well and I was asked back to do another collage art workshop. Again the artwork had to tie in with the topic set by the National Curriculum, which that year was 'Seaworld'.

SEAWORLD

This project again proved very enjoyable and was easier to direct because many of the children had taken part in the previous 'Planets' collage art workshop. The composition for this collage workshop also evolved from a mural commission. The finished work was on the same scale as that of the 'Planets', 92 x 366cm (3 x 12 ft). In preparation I produced an example of a collage showing the overall structure of how the collage might look with larger fish in the foreground, shoals of fish swimming around in various areas, rocks, stones and treasure scattered on the seabed. I explained that this example would act as a guide: they did not have to reproduce it and their painting would probably look very different. Templates of some of the larger animals were taken from this preparatory collage and provided for the children to draw around.

Teacher's sample Seaworld collage

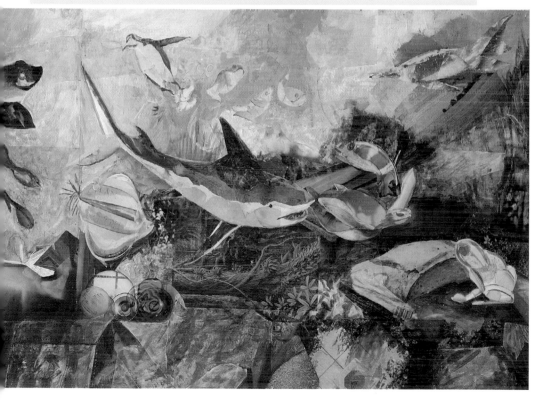

When organising a collage lesson or workshop I have found that it is helpful to provide not only appropriate books, but also items that are connected with the particular subject of the picture being produced. For extra inspiration on this project, I took some items that I had collected over the years while on summer holidays by the sea – such as shells, starfish, a piece of coral, driftwood and stones. I immersed some of the stones and shells in water in a glass bowl and some of the children became so enraptured with the vibrant colours of these objects when placed in water, they had fun playing and physically engaging with the subject matter by taking them in and out of the water.

The whole school, which included children from 3 to 8 years, took part in this project and the work was displayed in their school assembly hall. As before, the finished work was stapled to the fixed panels on the walls. This project was also linked to a musical the school were performing called 'Ocean Commotion' whereby they designed scenery using ideas and motifs from the collages already produced by the children.

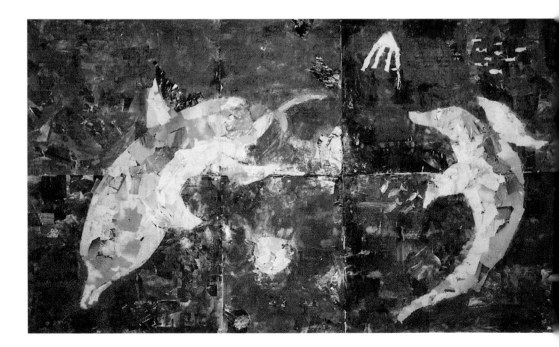

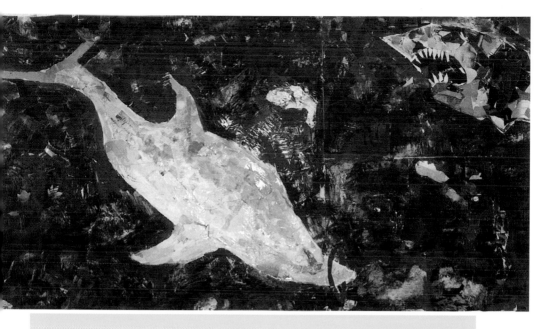

Children's finished Seaworld collages

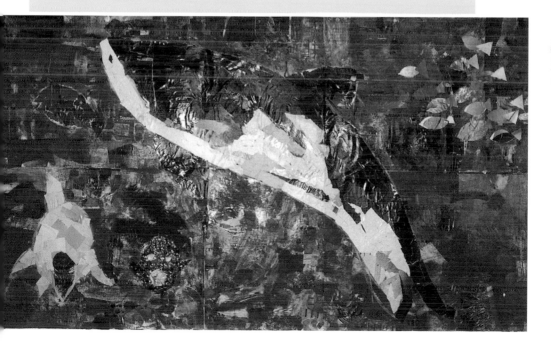

SHIPWRECK

Producing a collaborative artwork, where a number of artists contribute in the creation of one finished piece, such as a painting, piece of sculpture or photomontage, has become a popular and serious method of working for many professional artists. When I was asked to devise a collage workshop on the subject of a shipwreck for 20 children, aged 3 to 5 years, in a limited time period of just one hour and fifteen minutes, I chose to organise a collaborative project. This allowed all of the children, with different abilities and varying motivations, to participate in the production of a work of substance.

I was at first apprehensive about how this would turn out but after I had arrived at the school with my equipment, delivered a short talk, and showed examples of collages done by other children, the enthusiasm of the class was amazing and my fears melted away. The children had brought additional equipment and ideas that they thought might be suitable to use in the collage. It was wonderful. They had thought very carefully and imaginatively about the subject matter and the details of what one might find in or near a shipwreck lying on the seabed. Pieces of jewellery, beads, buttons and gold tinsel appeared – representing treasure that one would find – and bits of discarded fishing rope, and actual shells were applied to the finished piece. As this was a large-scale piece of work, I helped them with the initial image of the shipwreck. We began by painting in the background colours of blues, greens, yellow and

Stones and shells in a bowl of water

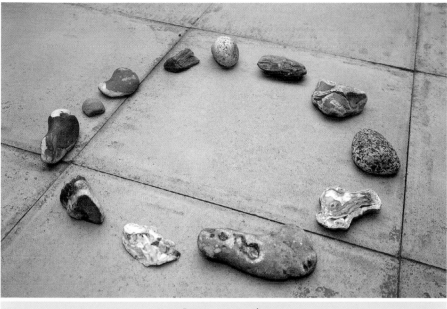

Stone circle

purple and defined the broken ship in black and brown. I found that this is a good method to use when organising a large collaborative collage. After the large areas have been covered with paint generally allow 10 minutes drying time before commencing the collage. This waiting time can be used to sort and select papers and other materials, and talk about the subject matter.

This was the first time I had started with paint, rather than paper, and the arrangement of painted colours made a good background on which to build-up the collage work, helping the children choose appropriate coloured paper. What was unexpected was that getting the project started in this way seemed to allow more time for the children to think creatively and come up with original ideas.

One teaching aid that I had used before worked very well again on this particular project. This was the shallow glass bowl of water containing shells, pebbles and small rocks. When some of the children got bored with collage, I encouraged them to identify the colours, and different shapes of these objects in the glass bowl and generally play with them. Stones and shells were taken in and out of the bowl and, as usual, they enjoyed splashing the water around. To my surprise and everyone's delight they created a small stone circle design on the floor of their own accord. Some of the children also used the stones and shells as templates to draw around, and it was exciting to see them beginning to explore and develop their own methods of working within this collaborative piece of artwork.

The addition of tactile objects in this picture creates a rich and lively effect. Strong glue and a staple gun had to be used to attach the objects to the surface – teachers and parents assisted with this task. The result is shown below.

With large groups one can choose collaborative or individual pieces, they both work well. Although when it comes to producing a work that is part of a topic from the National Curriculum, I find collaborative collage work preferable – the enthusiasm generated by some children assists those that are more reluctant, and at the end of the workshop everyone seems pleased to have participated.

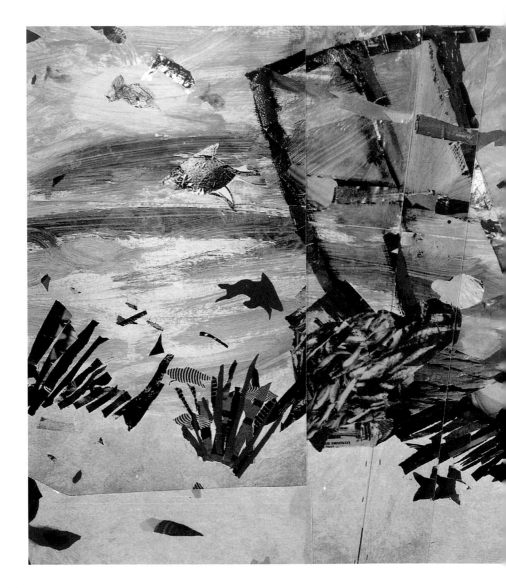

If it is going to be a collaborative piece, then all ages from 2 to 11 years can take part with the youngest having individual guidance from the teacher, teaching assistant or visiting parent on the areas they are going to contribute to. The presence of a parent or two in some of my collage workshops has been invaluable in achieving the intended outcome in both collaborative and individual artwork. Their guidance in helping very small children with the handling of materials such as scissors, glue, selection of coloured papers and painting has been wonderful.

Shipwreck collage

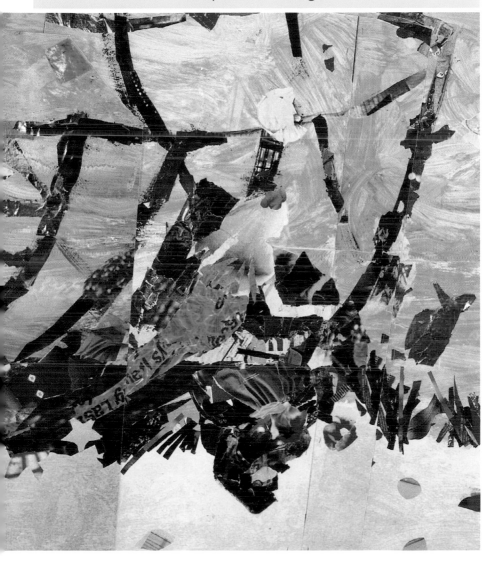

THE FOUR SEASONS

This project involved the production of four pictures over two days, one for each season, by children aged from 3 to 8 years old, split into four groups according to age. The composition, shapes and colours in the pictures evolved from general discussion with each age group, and also with the assistance of a sketch outlining the main compositions of each season, drawn out on the blackboard by myself during the discussion.

Boards were prepared in advance so that the children could see the size of their picture. We used mainly paper, although paint was applied to cover areas that became 'busy' with too many recognisable photographic images from the magazines conflicting with what the subject was meant to be about. If some photos appear by accident, and do not interfere with the overall intention of the piece of artwork, then that is fine.

The success of this project depended on good preparation. I suggested to each of the four groups that they think about the main colours required for their particular season. Once these were established I wrote these on the board. The paper was sorted in advance into colours and placed in flat boxes as shown in Chapter 3. It does not matter if they are in various shades or if there are other colours occurring within the main colour, as the presence of these can enliven the picture, be painted over or covered up with another piece of paper in the main colour.

Collage is a quick, flexible medium, although one or two problems can occur. For example, if there is too much glue applied the image can get lost, become fragmented and look confusing. This is especially true if there is too much of the type of glue that is white when initially applied. In this case one should wait a bit for the glue to dry and wipe off any excess. Paper that is wet or has too much glue is difficult to paint over. I recommend working on another area until the paper and glue are almost dry. This is usually fairly quick – about five minutes, and then you can apply paint. One can read to the children whilst waiting for paper, glue and paint to dry. Short periods of calm are a good thing, especially if there are several children working on one piece of work and getting over excited.

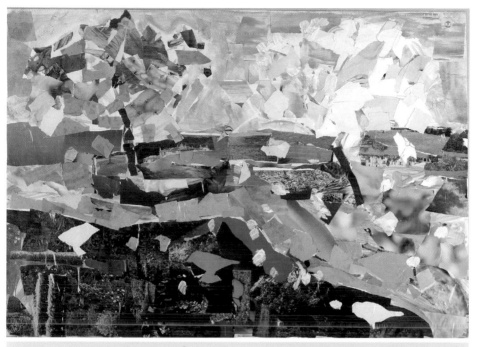

Collages of the four seasons: 'Spring'

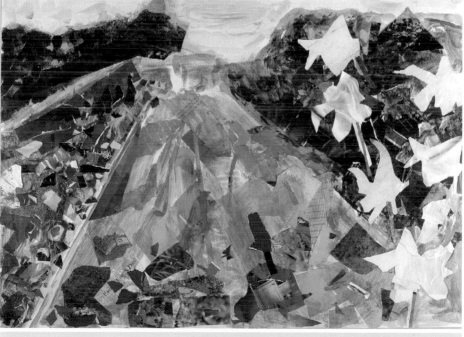

'Summer'

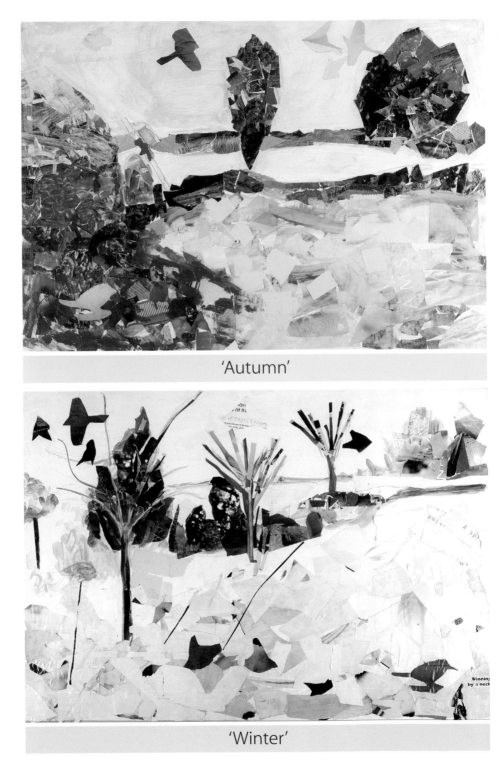

'Autumn'

'Winter'

5 Projects at the Zoo and Local Public Library

The Planets and Seaworld art projects had worked well with paper collage so I thought I would experiment with a similar workshop at the Battersea Park Children's Zoo. Children of various age groups arrived for this workshop, which was free. The Zoo had a Learning Room with a long table and some chairs, which was a great place to work in. Along one wall were glass boxes housing artefacts such as animal skins, and an assortment of stuffed birds and various other mammals and reptiles, with information about the animals' origins and how they came to be there. This was a wonderful resource and the children engaged immediately with this information rather than the animal books that I had brought to put on display.

ZOO WORKSHOP

The workshop commenced with a small introductory talk about the animals and how they could be represented in the medium of collage. I distributed simple questionnaire-style handouts to assist them in developing their ideas, recommending that they should choose one animal and think about colours, textures and setting.

The children were split into groups of four, and were instructed to tour the zoo and to select a particular animal as subject matter for their collage. They were accompanied by an adult who, in some cases, helped them to complete their questionnaire handout. I did notice that the adult helpers seemed to enjoy it as much the children, which was amusing.

Adjacent to the Learning Room was a small enclosure housing goats, sheep and rabbits and on that Saturday morning it was open to the general public. I encouraged the children to go into the enclosure and stroke them as part of a friendly, tactile learning experience. After about twenty minutes the children returned with their ideas and most of them had completed the handout – ticking the boxes and making little notes. However, one of the children, a little girl called Jojo, had a slight problem. She returned with only half of the handout because one very cheeky goat that she was stroking and befriending had started

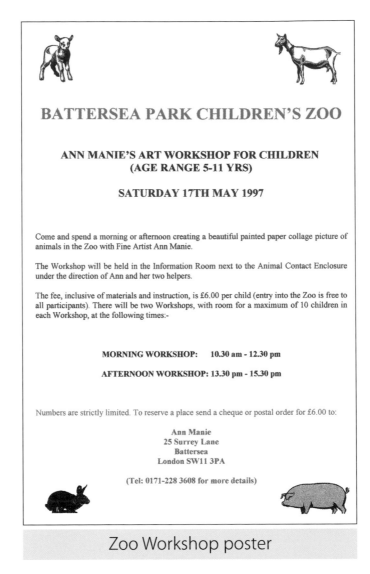

Zoo Workshop poster

to nibble at the paper – the teeth marks were clear evidence of this! Jojo was a little annoyed and switched her choice of animal to a pony. Calm was restored and by the end of the morning Jojo had produced a very nice picture.

I did an initial demonstration showing the children how to get started with their collage. I explained that small size cards were provided so that they would be able to finish their collage by the end of the morning. I recommended that they draw in their chosen animal first, either freehand or using one of the templates that I had prepared earlier. For my demonstration, I selected paper of three main colours plus black and white, and then began to fill in the colours of the animal first, working on the surrounding areas afterwards.

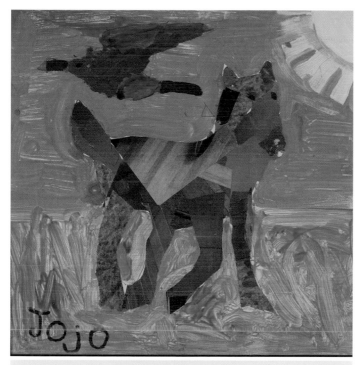

Jojo's Pony collage

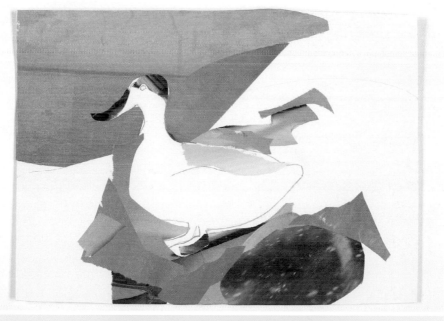

Part-completed Duck collage

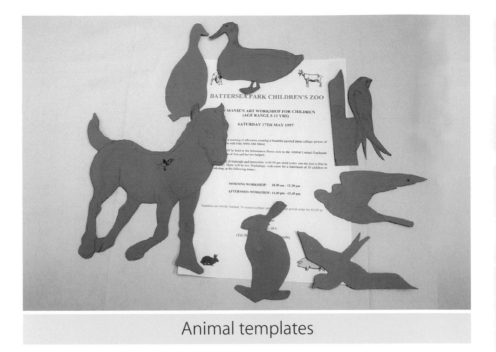

Animal templates

The lively and colourful collages shown below and on pages 45–48 were produced at this two hour workshop.

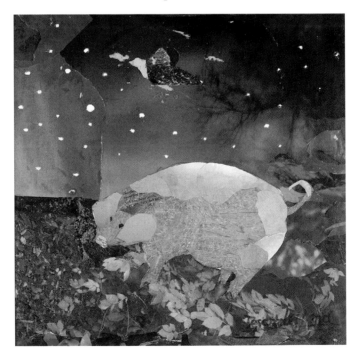

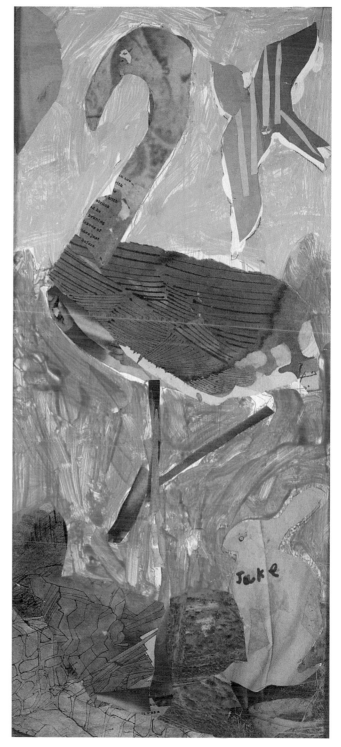

Collages from
Zoo Workshop

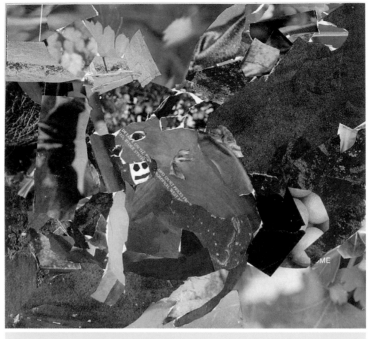

Zoo Workshop collage

LIBRARY WORKSHOP

The feedback from children and parents was so positive on this day that I felt encouraged to do another informal collage workshop at a local children's library. For both projects I produced a simple leaflet, which was displayed in various public locations two to three weeks in advance of the workshops. The local newspaper also advertised the workshops free of charge. At the library, some children came in response to the leaflet, but others arrived from the local school, accompanied by their teachers, to return and select new books as part of their English lesson. They were not expecting to do collage but most of them willingly had a go. Their teachers stood back and had an unexpected, but probably welcome rest while the children took part.

The scene was very amusing. I had prepared some equipment: a small amount of paper, scissors, glue, brushes and some books about the sea and marine life for inspiration. Some of the children were so enthusiastic they commenced cutting and pasting without even taking their coats off, and the library rapidly became noisy and rather chaotic. After about twenty minutes there were some surprising and intriguing results. One memorable piece of work showed a photograph of John Major embedded in stone at the bottom of what looked like the seabed – it was 1992 and he was still Prime Minister. At the time I thought this was an amusing observation of a child's view of a politician's lot.

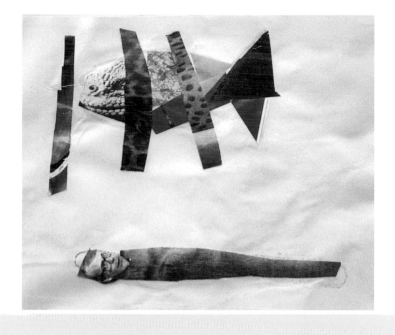

Collages from Library Workshop

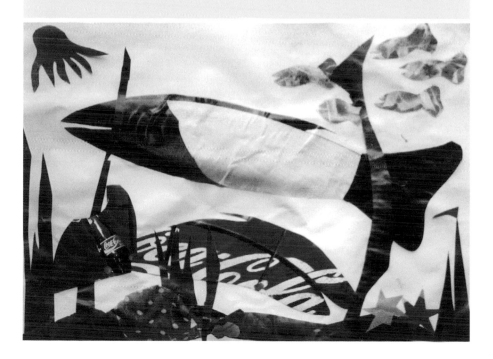

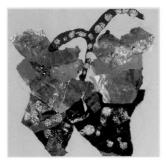

6 Drop-in Butterfly Workshop

After organising and directing several collage workshops with children, I was beginning to realise that paper collage is a medium with many possibilities. The subject matter one can choose to work with in the picture making process is rich and varied: still-life objects, landscapes, the planets, marine life, large animals and even small animals, such as bees, ladybirds and butterflies. On a visit to the Butterfly House at Syon Park in Brentford, Middlesex, I noticed that the strange and beautiful colouring of the butterflies would provide wonderful subject matter for a collage project on insects. One could be free and inventive when representing the coloured decorative pattern on their wings. I was delighted to be able to organise a collage workshop in the workroom at the Butterfly House. Children accompanied by their parents dropped into my free workshop after seeing the live butterflies at first hand.

To add to what they had already seen, I put out some display boards showing samples of butterflies from different parts of the world, which I took from a book on butterflies. The children were able to look at the varied range of butterflies and choose one to make a collage from. I presented a range of coloured papers for them to select for their collage – the blue and yellow coloured papers were very popular and I nearly ran out of them. I provided coloured card as well as white card for the children to work on and, surprisingly, many of them chose to use coloured card.

I introduced myself, the subject, the medium and demonstrated the method – cutting, tearing and pasting paper on to card to form the beginnings of a butterfly. The learning process was rapid, and after about 15 to 20 minutes some beautiful collages appeared. Many of the children added beads, glitter and other items such as coloured string, to the finished work. The children taking part in this drop-in workshop were aged from 2 to 11 years old.

With very young children whose attention span is perhaps limited, the following simple, quick and effective three-stage technique could be suitable:

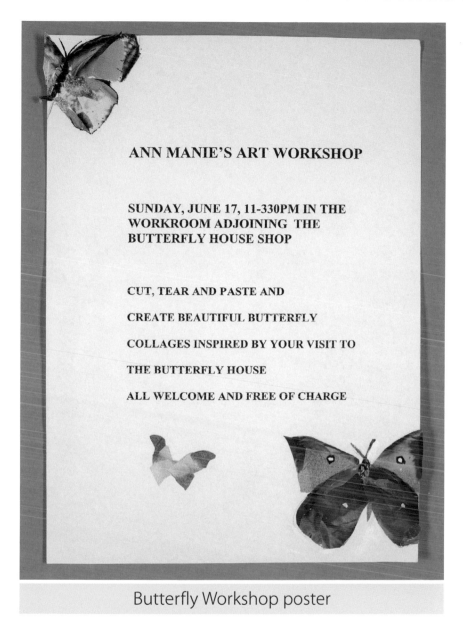

ANN MANIE'S ART WORKSHOP

SUNDAY, JUNE 17, 11-330PM IN THE WORKROOM ADJOINING THE BUTTERFLY HOUSE SHOP

CUT, TEAR AND PASTE AND

CREATE BEAUTIFUL BUTTERFLY

COLLAGES INSPIRED BY YOUR VISIT TO

THE BUTTERFLY HOUSE

ALL WELCOME AND FREE OF CHARGE

Butterfly Workshop poster

- draw and cut out separate shape of butterfly about 8 x 10cm (3 x 4 in.) from thin card
- paste decorative paper and other materials on to this
- when finished, attach it to a larger sheet of card or paper

This approach makes it possible for a young child to create a collage quickly, without too much pasty mess.

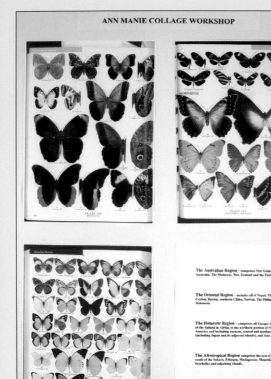

Butterfly display boards

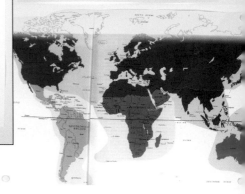

Collage materials

Collage materials

The Butterfly Collage is a wonderful subject matter that can be arranged at virtually no cost, and does not necessarily have to be based at a Butterfly House. Children can research and perhaps locate photographs of butterflies and insects from magazines or books they might have, or be able to borrow from their local library, as well as the school library.

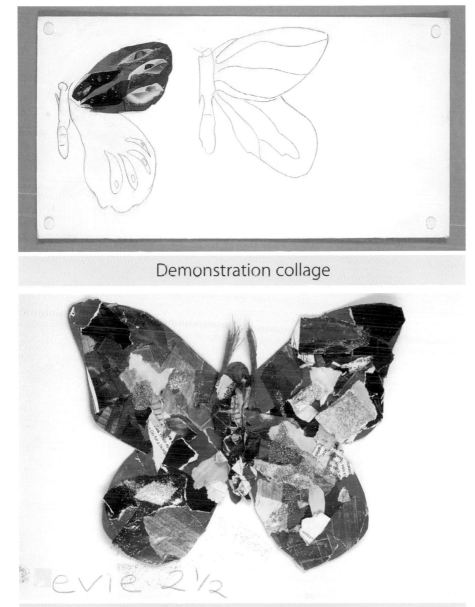

Demonstration collage

Butterfly collage by Evie

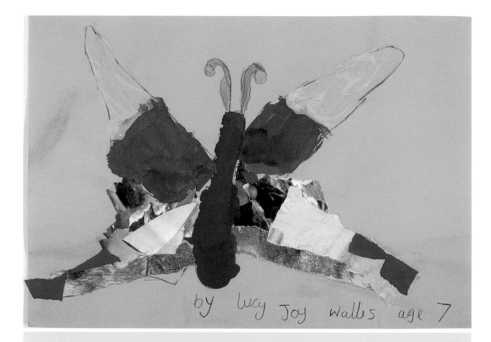

Collages from Butterfly Workshop

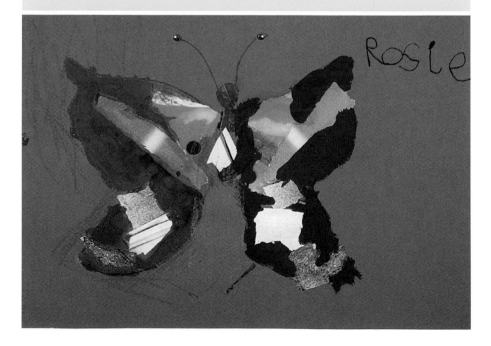

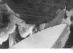

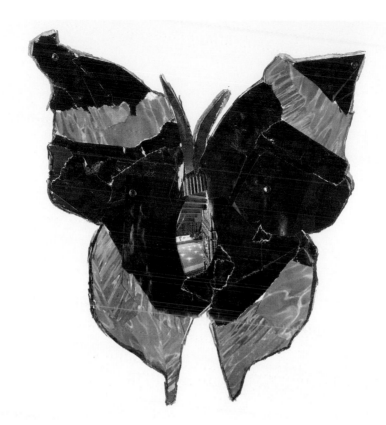

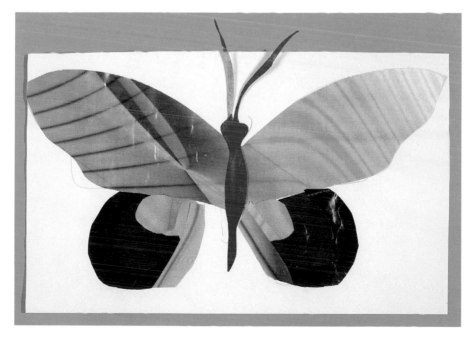

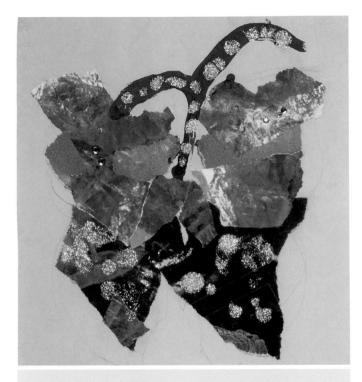

Collages from Butterfly Workshop

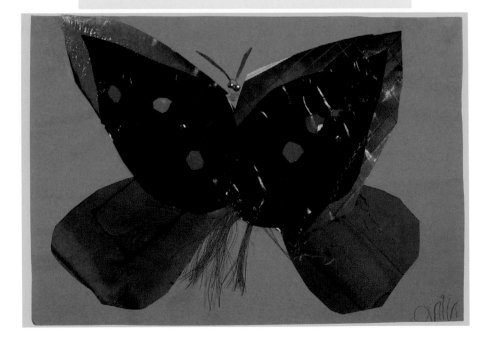

7 Using Museums and Galleries

Museums and galleries are wonderful sources of inspiration for many types of projects and collage art projects are no exception. Physical exposure to an original artefact whether it is a piece of meteorite rock or an old master painting is often very different to the photographic representation. In my experience, it is usually the colour, scale and texture that evoke the most surprise. The colours are usually lighter in the original painting than one is led to believe from a photographic image and the surface is not always as smooth – the paint is often actually quite thick and raised from the surface of the canvas.

I felt this to be so when I first looked at the Impressionist painter Claude Monet's oil painting of water-lilies at the Tate Modern gallery in London. Apart from being overwhelmed by the grand scale of the painting, the quality of paint was very textural – with dashes, swirls and other shapes almost hovering over the surface of the canvas – and the colours and tones were lighter than I had expected. The Impressionists evolved during the late 19th and early 20th centuries and, as is well known, their aim was to capture the effect of fleeting light on the world in their pictures, whether it be landscape, urbanscape, figures, portraits or objects. They did not use black and generally painted in small daubs of colour. Although by 1926, when Monet painted this particular picture, he was combining painted daubs with free flowing marks, such as swirls and larger areas of one colour. Some well-known original paintings are not always recognisable when viewed up close and this was apparent with the water-lilies – close up they appeared completely abstract, there was no recognisable imagery. When one steps back a few feet, the shapes of the flowers become identifiable.

As well as challenging one's preconceived notions about the visual tactile world, I believe visits to museums and galleries can be profoundly enriching learning experiences for everyone. Such visits, if they can be arranged, can stimulate interest and ideas in advance of a collage art class.

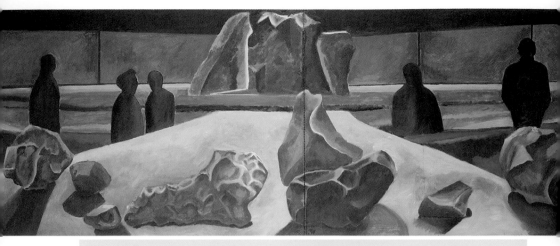

Meteorite Hall, Ann Manie, oil on board 76 x 203 cm

MINERALS AND METEORITES

I recently took some boys of 4 to 11 years of age to the meteorites and minerals galleries at the Natural History Museum, before returning with them to my studio where they produced individual collages. The meteorites we saw on display there were surprisingly small and the colours were mainly varying shades of grey and brown, with a textural surface of circular dimpled indentations.

Much has been said and written about the origin of meteorites. They are described as 'falling rocks from outer space' coming mainly from the Asteroid Belt between Earth and Mars, and also from the Moon. The meteorites themselves were not particularly visually exciting but the stories about their origins, what they were made of, and where and when they fell were interesting and sometimes amusing, bringing them to life. There was a photograph of one that had crashed onto the bonnet of a car, creating a substantial dent. I wondered what the insurers would have made of this – it was not typical car crash damage!

The children participating in this project were particularly fascinated by the vast array of minerals and the everyday items that are derived from them. Attractive minerals such as quartz were especially of interest and the jewellery made from this was much admired. The cabinets containing minerals were numerous and the variations, colours and textures of the minerals on display was extensive. These proved to be very popular when the boys were looking for raw material for the collage.

Handouts – Museums and Galleries

Encouraging the children to make a few notes by asking them to complete a simple questionnaire of their observations whilst visiting museums and galleries is a good idea, regardless of whether or not it is an art project. With collage projects, however, I think it is a particularly valuable tool in order to stretch the children's creativity and also to promote an interesting question and answer session during the lesson. Even if the visit has taken place a few

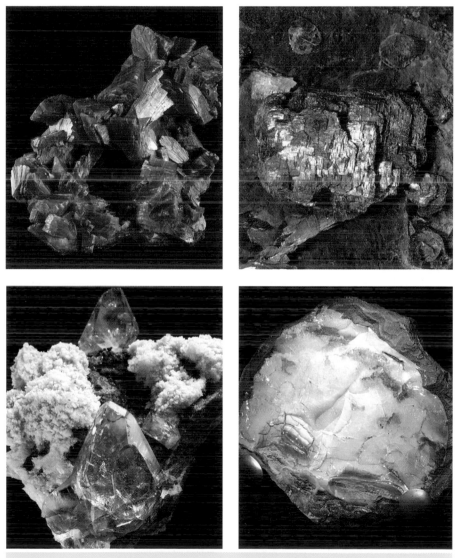

Minerals and Meteorites

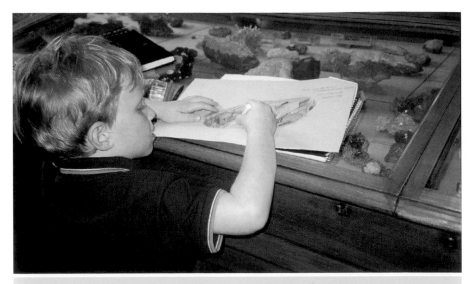

Boys preparing for collages in Natural History Museum

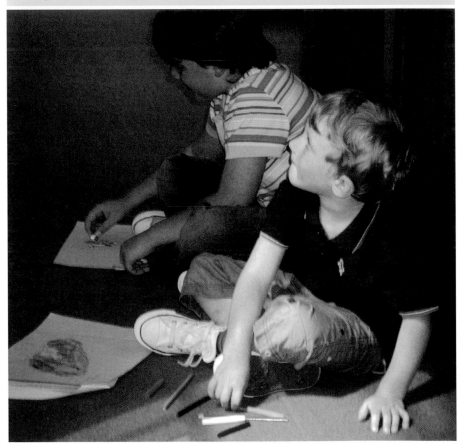

days before the art class in school, the children have their completed handout to remind them of what they saw and how they visually engaged with the objects or works of art. It is a useful guide and is invaluable to the construction and development of a piece of collage artwork.

VISIT TO THE NATURAL HISTORY MUSEUM, MINERALS AND METEORITES

Create a collage of a mineral or meteorite inspired by your visit to the mineral and meteorite galleries at the Natural History Museum. In order to assist you there are a few questions listed below that you could answer once you have made your choice of mineral or meteorite.

Make a sketch of the mineral or meteorite on the attached piece of paper using crayons, and then write or draw in the answers to the following questions.

1. Colours or colour – write down or draw in the colours.

2. Shapes – are there circles, ovals, squares, rectangles or lines. Thick or thin bands of light or dark shades? Write down or draw these.

3. Texture – What is the appearance of the surface of the meteorite or mineral? Smooth or slightly rugged, or both? Is there an irregular or regular pattern of lines, dots, curves or swirls? Draw them in the space below.

4. When returning to the art class use the drawings to make a landscape picture using pasted paper collage and some paint (paint optional).

5. Make a note of the name of the mineral and place of origin and any object that might be derived from it.

Sample Handout

Crystals with Calcite, Kornas Mine

COLLAGE WORKSHOP
MINERALS AND METEORITES

Create a collage inspired by your visit to the Mineral and Meteorite Hall at the British Museum using this instruction sheet.

Make a sketch of the mineral or meteorite on the attached sheet of paper using crayons and then write or draw in the answers to the following questions. This will help you remember the details of your choice of mineral or meteorite later as you work on the collage.

1. Colours or Colour – write down or draw in the colours

2. Shapes – are there circles, ovals, squares, rectangles, lines. Thick or thin bands or light and dark? Write down or draw These.

3. Texture – What is the appearance of the surface smooth or rugged in appearance. Is there an irregular or regular pattern of lines, dots or swirls? Draw them in the space below

Completed handout, preparatory sketch and
finished collage

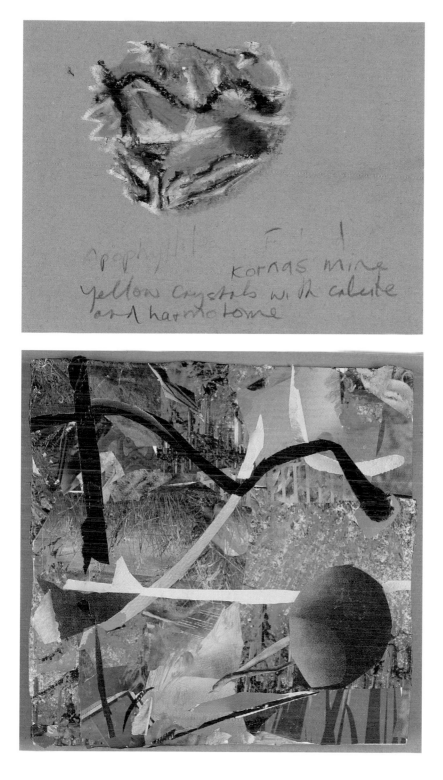

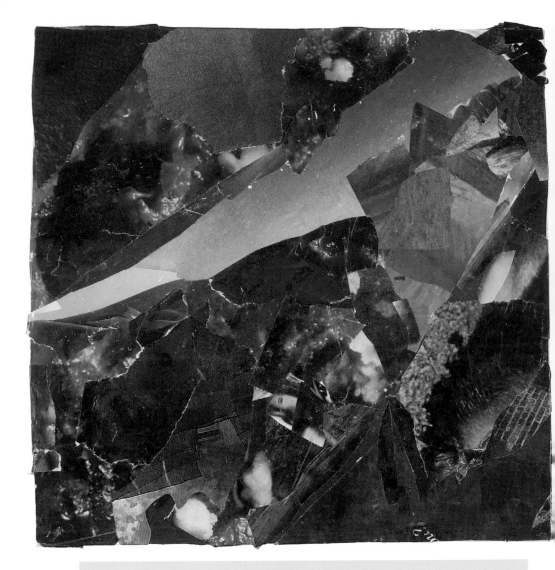

Further finished collages of minerals

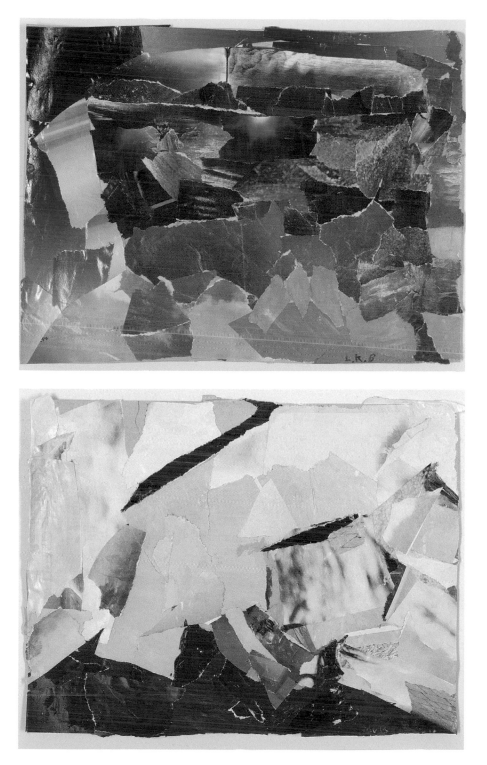

COLLABORATIVE COLLAGE INSPIRED BY CLAUDE MONET'S 'WATER-LILIES'

I recently organised a workshop with schoolchildren to produce a collaborative collage of Claude Monet's *Water-Lilies* painting, but due to time constraints and other lessons it was not possible for the children to actually visit the Tate Modern and view the original painting. I therefore devised a project which could be carried out entirely from the school. A few days in advance of this lesson, we looked at the painting in a book about the Impressionists. The choice of painting worked well with the topic of 'Colour and Light', which they were studying as part of the National Curriculum for that year.

As with previous collage workshops and lessons I felt that it was important to commence the session with a short talk about the subject, briefly mentioning some factual information and historical details. I found it helpful to display, on a board, an enlarged colour photocopy of the painting. I explained that the lily ponds were located at Monet's home in Giverny, north-west of Paris. I displayed a map of France and physically identified the place and its relationship to Paris, the rest of France, and England. Monet produced a series of paintings about the lily ponds. This series of paintings was about recording the fleeting quality of light and atmosphere at different times of the day on the surface of the ponds. Apparently he built a huge studio in his garden and erected large canvases on specially constructed easels by the lily ponds, which his gardeners

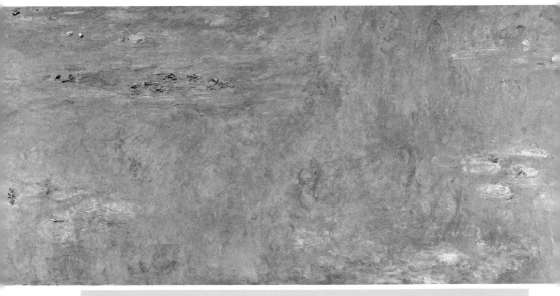

Water-Lilies, Claude Monet, oil on canvas, 200.7 x 426.7cm

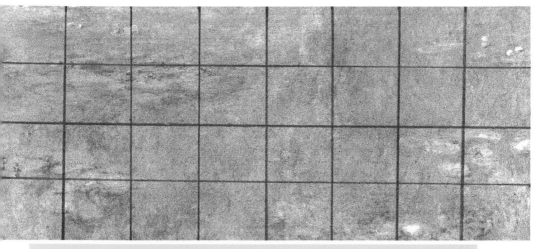

Grid overlaid on postcard image of Monet's *Water-Lilies*

TOP	TOP	TOP	TOP	TOP	TOP	TOP	TOP
1	2	3	4	5	6	7	8
TOP	TOP	TOP	TOP	TOP	TOP	TOP	TOP
9	10	11	12	13	14	15	16
TOP	TOP	TOP	TOP	TOP	TOP	TOP	TOP
17	18	19	20	21	22	23	24
TOP	TOP	TOP	TOP	TOP	TOP	TOP	TOP
25	26	27	28	29	30	31	32

Numbered back of postcard

shifted for him as the light changed. He painted about 19 paintings of this size and subject.

Lily-pads, weeds, plants with hints of red magenta flowers, grass and reflections are depicted with a combination of thick and thin paint applied in a variety of shapes, swirls, patches of broken and uneven paint. When one takes a closer look at this picture, one feels immersed in paint. Monet seems to have created an illusion of a world without end. There is no horizon line to indicate the type of space one is peering into – is it deep space or shallow space? One child made the comment that 'one could almost jump into it' – and this remark evolved from looking at a small-scale postcard reproduction! Although it is

nearly 100 years since Monet painted this picture its visual power is undiminished by the passing of time. While at the gallery I noticed many people stopping and gazing for long periods at this picture, clearly fascinated by it.

In order to organise and create this collaborative work I purchased two postcards of the painting. One was divided and cut into 32 squares, the same as the number of children participating. I numbered each piece on the back appropriately, as well as marking the correct orientation (i.e. 'top') so that we would be able to place the pieces in the right order (and the right way up) when assembling the finished work. The other was to provide an overall reference, as and when required, especially if one needs to look at the complete picture when putting in the finishing touches.

Finished collage inspired by Monet's *Water-Lilies*

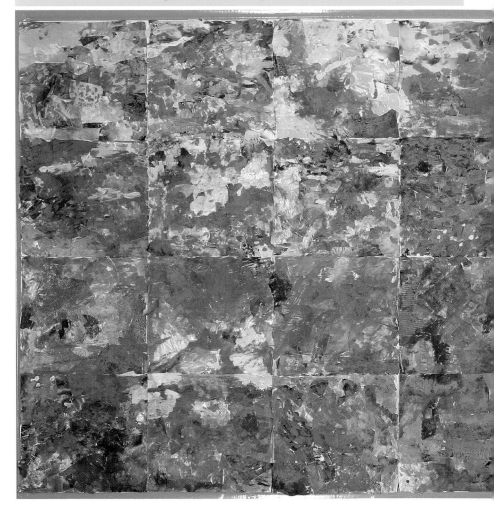

The children were asked to each a create a collage on a piece of card measuring 26 x 25 cm (10.2 x 9.8in.), copying the colours and shapes from the piece of the postcard they were given as closely as possible. We scaled the picture down to approximately a third of the original size which is 200.7cm x 426.7cm (6.5 x 14ft.). Coloured papers that are similar to those in the original painting were selected – yellow, blue, green, mauve and small touches of red. They were also free to use other materials in these colours if they wished – fabrics, beads, tinsel etc. as well as paint, provided that they were of a similar colour and tone to the painting. However, they all chose paper and paint on this occasion.

A few days later the pieces of collage were assembled onto a large rectangular panel. I used a staple gun to attach them to the surface of the panel. Staples are strong and adhere effectively to most types of surfaces; they

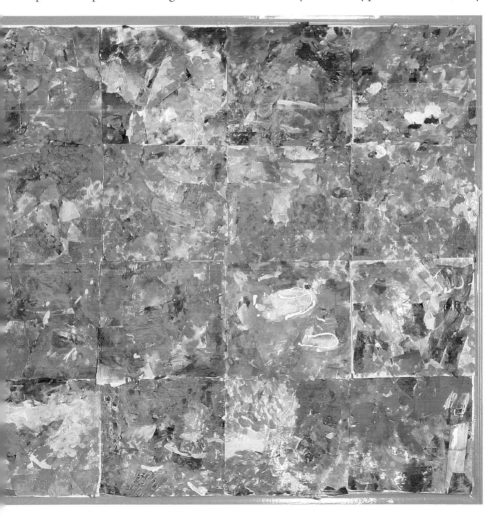

are also visually discreet, and generally do not interfere with the overall appearance of the work. If they do, they can always be covered by an appropriate piece of coloured paper or a touch of paint.

One can try this with any painting or piece of sculpture, but the more complex it is the more time it will take to complete. Landscape, rather than urban scenes or figures, is preferable subject matter when producing a collage interpretation of a famous painting with children aged 4 to 11 years. The children will be less likely to worry about recognisable objects and getting things exactly right, and are more free to think imaginatively and let exciting shapes and lines occur, as they cut and paste the paper (any mistakes can be covered over with more paper). I would not rule out the possibility of attempting a project of urbanscapes and figures but they are complex and require more time than 45 minutes, which is the usual period for a typical school lesson. Out-of-school workshops are better for more complex designs because these usually run for two hours. Alternatively, such a project could be conducted over several school lessons, but the enthusiasm and interest in the project may be lost.

8 Further Projects

In this chapter, I describe some other ideas that have developed from previous collage workshops. The topics are simple and relatively easy to organise, wherever one might be, and the equipment and source materials should generally be close to hand.

COLLAGE SELF-PORTRAIT

Painting a self-portrait is considered by many to be an artist's most personal form of expression. Some might remark that it is an opportunity for self-reflection. This notion is probably a little advanced for children aged 4 to 11 years old, whose life experience is still in its early stages, but nevertheless it can provide the basis for an interesting and fun project.

For this workshop I began the lesson by showing some colour photocopies of examples of self portraits by famous artists, and some portraits they painted of other people, especially children. These were pinned to a drawing board, and displayed so that they could be seen easily by the whole class. I included some of Auguste Renoir's portraits of children because his technique appears quite simple: rounded face, almond-shaped eyes. On closer examination some of the main facial features such as the nose, mouth and cheeks are represented by lightly applied dots and dashes. These touches and dabs of paint can make portrait painting seem easy. The children remarked that Auguste Renoir's faces looked contented and happy.

Looking at the display of coloured photocopies of self-portraits we discussed and reflected upon the reasons why artists have painted their own image. Rembrandt painted himself many times during his life thus recording his changing appearance from youth to middle age. We examined a portrait by Vincent Van Gogh, who often painted himself because he was poor and could not afford to pay for someone to sit as his model.

The Impressionist artist Claude Monet took a photo of his own image that was reflected on the surface of a pond in his garden. This was around 1916 when he began to paint his series of water-lilies pictures. Water is a good reflector of

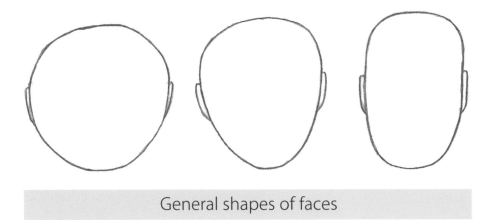

General shapes of faces

the self-image. An idea for a workshop might be to make a collage of the reflected self-image on a shallow pond – preferably on a sunny, windless day with plenty of space to spread the equipment: boards, scissors, paper and paste etc.

In my class, I drew attention to the fact that the non-distorting flat glass mirror was first manufactured in Venice around 1600, and showed a map of Italy to identify the city. The information that, according to scientists, only humans and chimpanzees can recognise their own image provoked much amusement among the 5 to 6 year olds in this class.

The lesson was an observational exercise, with the aim of encouraging children to explore with coloured paper the unique components that make up their own face. Firstly, looking at their faces in the individual mirrors provided, they were asked to identify the overall shape of their face and draw this out. They then examined the tones and colours of their skin, eyes, eyebrows, nose, mouth, ears, lips and hair, and selected papers from the boxes that were roughly equivalent to these. As a guide, I showed them a sample drawing of the three overall shapes that one generally sees when looking at a person's face for the first time.

It is important to point out that as one looks more closely at faces they sometimes have two or all three elements of the above categories: rounded chin and cheek bones with a longish square shaped forehead; rounded face with angular jaw line etc. We identified each other's faces to highlight this fact. Once the general face had been drawn out and the flesh tones selected from the paper palette and pasted on the board, the next step was to identify and lightly draw out the shape and position of the eyebrows, eyes, nose and mouth.

The difficult part is usually the nose and I encouraged the children to look at the shadows and shades around the bone of the nose and nostrils which should enable them to express this feature. Once the shapes around the nose area have been sketched in it is easier to start working on the other features.

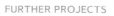

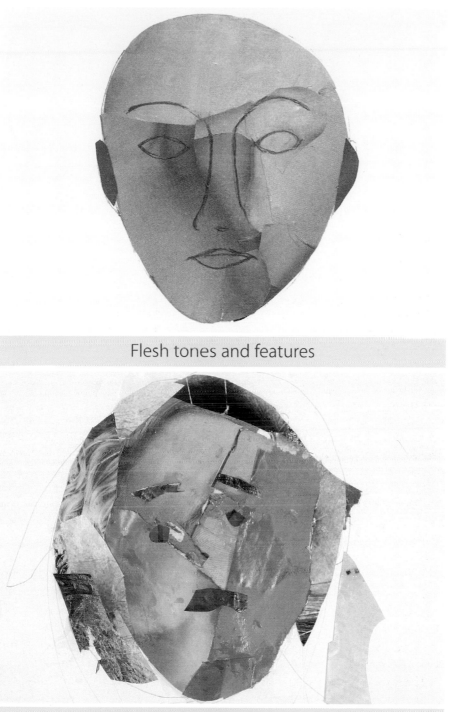

Flesh tones and features

Child's self-portrait

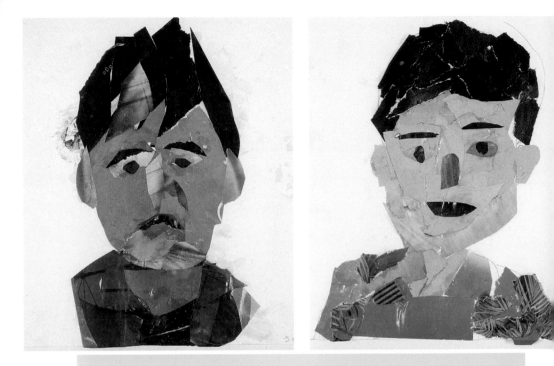

Children's self-portraits

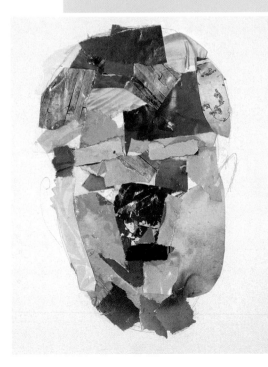

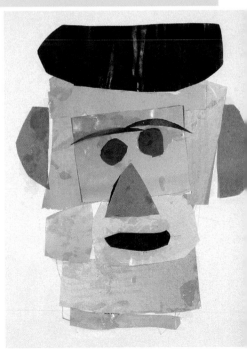

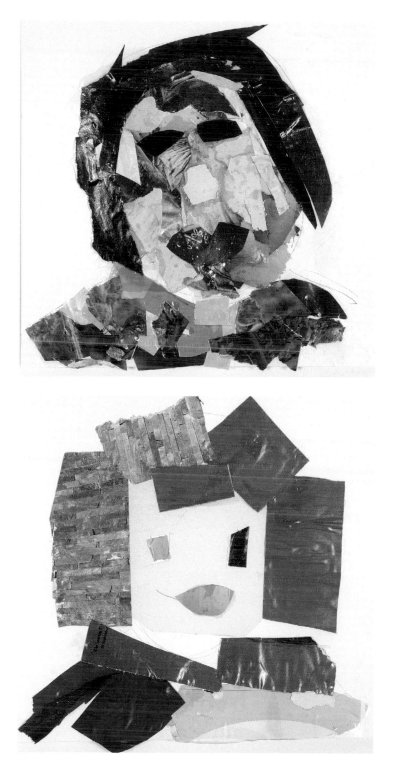

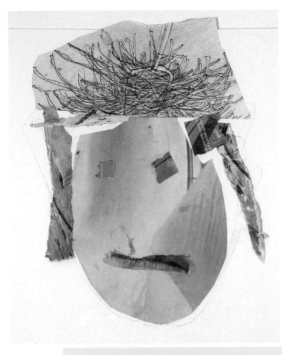

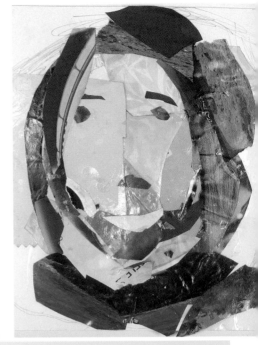

Children's self-portraits

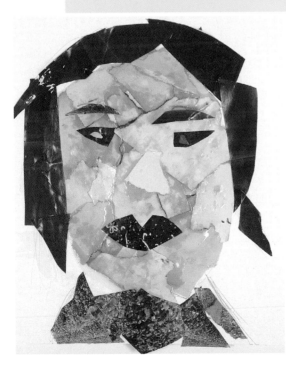

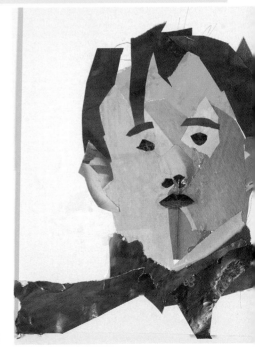

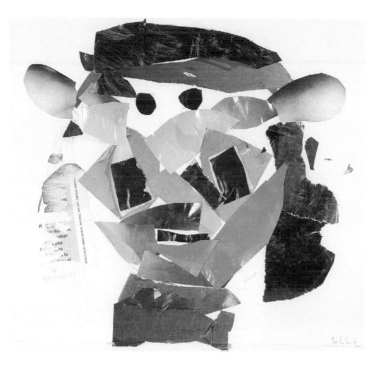

Introducing the lesson with a few amusing anecdotes and facts helps to make this topic interesting and, perhaps, less awesome than it really is and creates a mood of willingness to have go. How can one truly measure success? Capturing a likeness is subjective, each person's view of themselves is different to how others seem them – possibly echoing a familiar phrase: 'one does not always see oneself as others do?'

ANIMAL, VEGETABLE AND MINERAL

This workshop, which is about investigating the world and most of the things that surround us, was inspired by my visit to the mineral and meteorite galleries at the Natural History Museum in London. Studying the qualities and properties of minerals encouraged me to think about using collage for a project incorporating animal, vegetable and mineral – the substances from which everything we use, wear, eat and drink, are derived from. Looking, exploring and discovering the origins of things that are fundamental to our everyday existence is fascinating, and proved to be a good topic for a workshop.

This subject is slightly more complicated than many of the others covered in this book, especially when children are producing their own pieces of artwork, and it is probably best suited for older children. It would be helpful if the children were to prepare for this project a few days in advance of the lesson in order that they might complete their collage in a 45 minute time

limit. For example, as homework, they could choose any item and explore its origins using libraries, the internet and general discussion with family and friends. If there is not the time to prepare, ideas and inquiry can be generated by creating a handout such as that suggested opposite.

When I organised this lesson it was with children aged 6 to 7 years old who had not made any preparation for this subject. I did not distribute the handout as I felt it would be too advanced. Instead, I used it as an introductory explanation, followed by a ten minute question and answer session, and then spent a further five minutes showing images from reference books:

- books which covered topics such as rocks, minerals and wood, and the origins of: plastic, cotton, wool, glass, rubber
- books about a wide range of foods and processes that occur in order to produce some of them: chocolate, coffee, sweets, bread, dairy products such as milk, cream and butter, salt and pepper
- books and images about fruits, vegetable, fish and meat.

From these we were able to establish the origins of many items and easily categorise them. We talked about the things we need in order to function, and to gain pleasure from – things such as food, drink, accommodation, clothing, footwear, sport, body creams and sprays, cooking utensils, furniture, cars, trains, aeroplanes, computers and various other machines. These are all linked in some way either to the organic – the living thing – or the inorganic – the non-living thing. I explained that materials produced by plants, vegetables and animals are organic, and that items derived from minerals are regarded as inorganic because they are not made by living things.

ANIMAL, VEGETABLE AND MINERAL

1. Select and explore the qualities of an item from your daily life. It can be something you use, eat, drink, wear, is a pleasurable pastime such as sport, dancing, playing a musical instrument or a thing you love! Write down on a separate sheet of paper which category it might belong to: organic – animal or vegetable, or inorganic – mineral. Perhaps it is linked to both?

2. Using personal knowledge and possibly images from the reference books displayed, make a drawing of the item on the piece of card you will use to create the collage on. Include in the drawing any information that is connected with it such as its origins, where and when it is used etc.

3. Only a few shapes indicating ideas need be drawn in (the paper palette will provide extra ones as you work).

4. Select an assortment of papers choosing relevant colours and shapes, scissors and a brush or spreader to put the glue on with. Start to cut, tear and paste the paper, working around the drawing. Don't be afraid to make a mess or lose some details of the original drawing – exciting shapes and things can occur if you let go. It is advisable to put in the large shapes first and then the smaller ones later.

5. Sample collage: *A Cup of Tea* – vegetable: tea leaves, mineral: cup and saucer derived from clay from the ground.

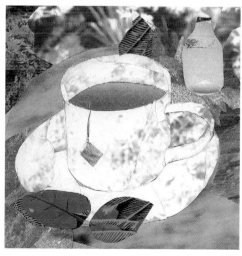

Sample Handout

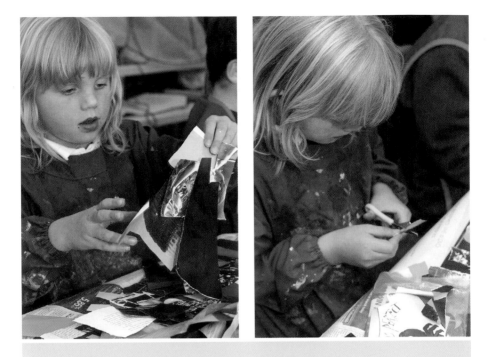

Animal, Vegetable and Mineral Workshop

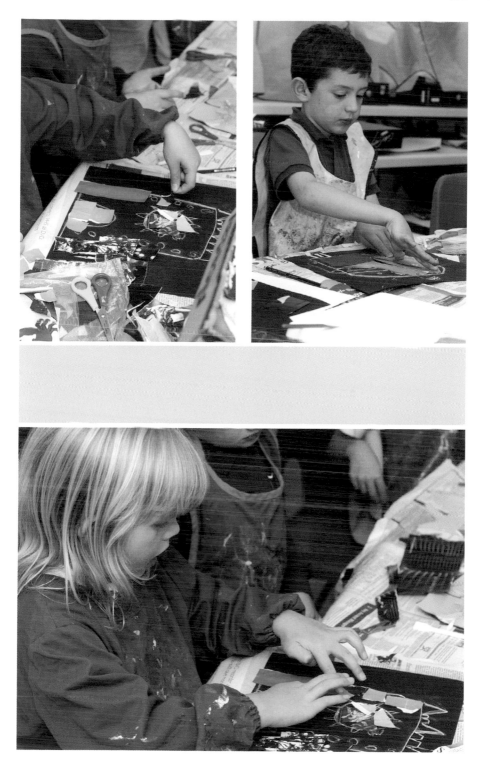

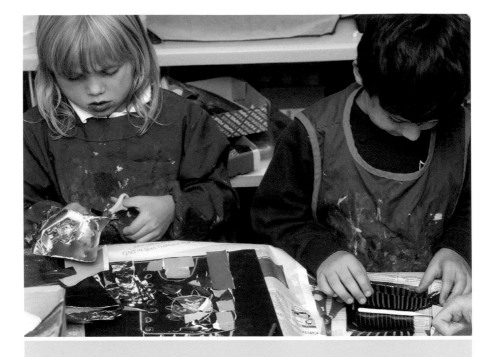

Animal, Vegetable and Mineral Workshop

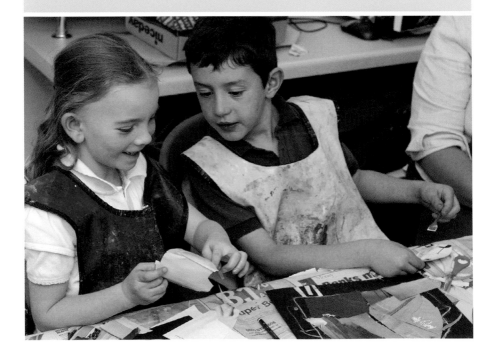

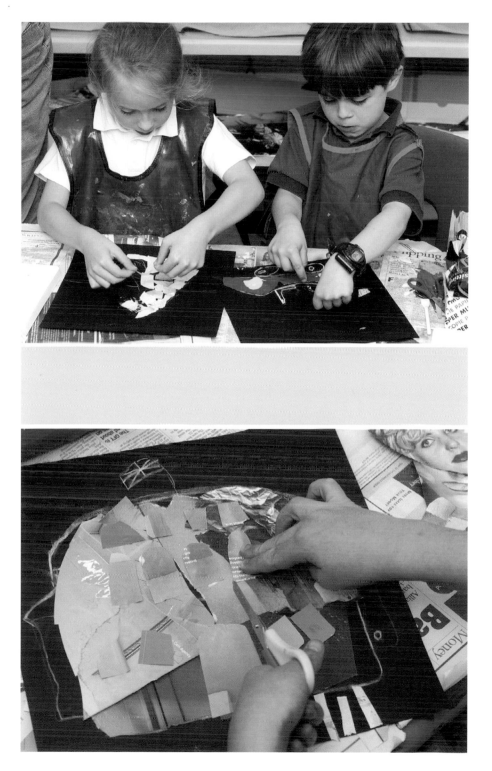

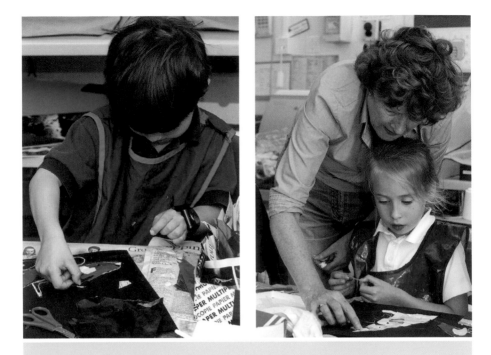

Animal, Vegetable and Mineral Workshop

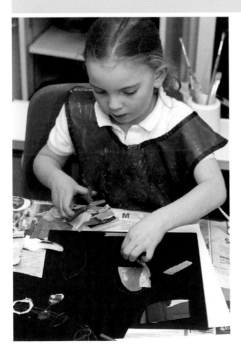

It is such a vast subject that one cannot possibly know everything, but for the purpose of a collage art lesson it is preferable to keep things simple and perhaps pick one thing to make a collage from. The children worked out their ideas quite quickly and there was a lot of enthusiasm. Some of the children took it in a direction of their own. Some collages were more successful than others, but most understood the aim of the project and produced almost finished work within the 45 minute time limit. One child liked looking at the minerals and made a collage of a necklace showing the gems that were derived from them. Cars were very popular with boys and those that chose this as their subject were more interested in the shape, colour and overall look of the vehicle rather than its origins. Many were happy just to choose a favourite toy, pastime or animal – often their pet cat or dog.

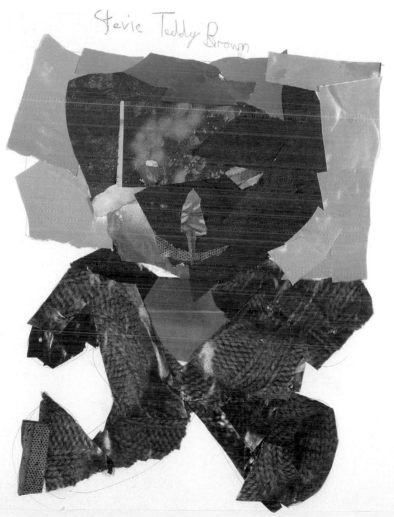

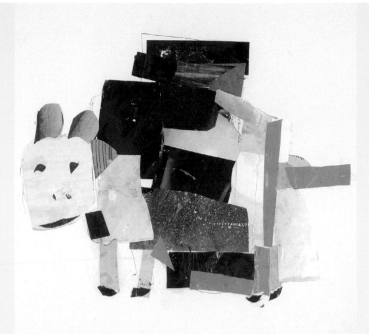

Animal, Vegetable and Mineral Workshop

Animal, Vegetable and Mineral Workshop

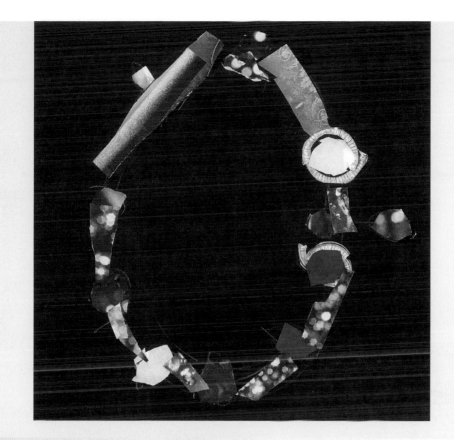

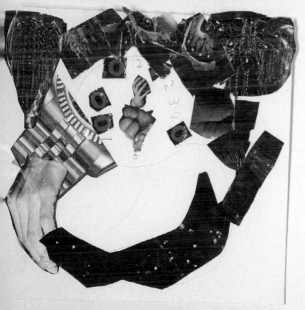

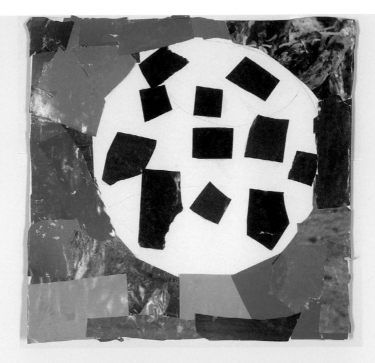

Animal, Vegetable and Mineral Workshop

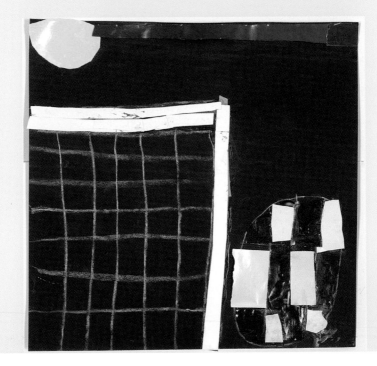

Conclusion

This book on collage has been about the exploration and discovery of different combinations and qualities of colours, shades and textures of magazine paper and how they can be linked with various subject matters in creating a work of art that is of primary importance. The addition of other materials can be used to perhaps enhance and add sparkle to the finished piece.

Selected Suppliers of Art and Craft Materials

Alec Tiranti Ltd
27 Warren Street
London W1T 5NB, UK
Tel: 020 7636 8565
www.tiranti.co.uk

Atlantis Art Materials
7-9 Plumber's Row
London E1 1EQ, UK
Tel: 020 7377 8855
www.atlantisart.co.uk

Baker Ross Ltd
2-3 Forest Works
Forest Road
London E17 6JF, UK
Tel: 0870 4585440
(*Ideas Store for Arts and Crafts*)
www.bakerross.co.uk

Battersea Arts Centre
295-297 Lavender Hill
London SW11, UK
Tel: 020 7228 7271
www.bac.org.uk

GLS Stationery (Educational Suppliers)
1 Mollinson Avenue
Enfield EN3 7XQ, UK
Tel: 08451 203213
(*Card, Paper and Glues*)
www.glsed.co.uk

Green and Stone
259 Kings Road
London SW3 5EL, UK
Tel: 020 7352 6521
www.greenandstone.com

Nes Arnold
Gregory Street
Hyde
Cheshire SK14 4SG, UK
Tel: 0845 1204525
(*Suppliers of art and craft materials such as sequins, buttons and coloured braids*)
www.nesarnold.co.uk

Bibliography

Bernard, Bruce, (Edited), *Vincent by Himself*, Orbis Publishing Ltd, London, 1985

Clark, Kenneth, *Looking at Pictures*, 5th Edition, John Murray, London, 1972

Cottington, David, Movements in Modern Art series, *Cubism*, Tate Gallery Publishing Ltd, London, 1998

d'Abrera, Bernard, *World Butterflies*, Hill House Publishers, Melbourne and London

Golding, John, Sophie Bowness, Isabelle Monod-Fontaine, *Braque The Late Works*, Royal Academy of Arts, London, Yale University Press, New Haven and London, 1997

Gombrich, E H, *The Story of Art*, 13th Edition, Phaidon Press Ltd, Glamorgan, 1995

Green, Christopher, *Juan Gris*, Whitechapel, 1992

Hynes, Margaret, *Rocks & Fossils*, Kingfisher Publications Plc, London, 2006

Kaufman, Elizabeth Elias, The Masters Collection, *Rembrandt*, Ottenheimer Publishers Inc. USA, 1980

Kerrod, Robin, *Nasa Visions of Space*, Prion, London, 1990

Mayer, Ralph, *The Artists's Handbook of Materials & Techniques*, 5th Edition, faber and faber, London and Boston, 1991

Miles, Lisa, *Rocks & Minerals Sticker Book*, Usborne Publishing Ltd, London, 2006

Murray, Peter and Linda, *The Penguin Dictionary of Art & Artists*, 7th Edition, Penguin Books Ltd, Harmondsworth, 1997

Poggi, Christine, *In Defiance of Painting: Cubism, Futurism and the Invention of Collage*, Yale University Press, Yale,1993

Rideal, Liz, *Insights Self Portraits*, National Portrait Publications, London, 2005

Russell, Sara, Grady, Monica, *Meteorites,* 2nd Edition, Natural History Museum, London, 2002

Thomas, Denis, *The Age Of The Impressionists*, Hamlyn Publishing Group Ltd, Twickenham, 1987

Thomas, Denis, *Everyone's Book of The Impressionists*, Hamlyn Publishing Group Ltd, London, New York, Sydney, Toronto, 1981

The Links Series of books on Plastics, Bricks, Electricity, Gas, Glass, Oil, Paper, Plastics, Steel Water, Wood, other books about Rocks and Minerals and the Food Chain.

Index